TRIPPIN(

CANVASES

How To Become

A Successful Artrepreneur

D O N T A E T M U S E

Preface

Art allows us to examine our humanity, to express what we might find hard to say and to come together with people we wouldn't have met and be open to ideas we would have never imagined. It lasts even longer than books and stories and is the oldest teller of history because most often the physical structures (architectural designs) are the only remains of civilizations. Art beautifies and sustains, but, who sustains the artists?

Very few artists/creatives are afforded the luxury of being able to be creative full-time and maintain a sustainable and/or lucrative income. A significant amount of people with creative talents are and/or would be struggling to make ends meet if they had to rely solely on their artistic abilities to provide sufficient income.

Most people dream of being able to do what they love to do all day every day and have those actions produce an income large enough for them to be financially free. If one had the choice of playing golf, video games, or reading all day and either of them being able to support two vacations a year, all bills paid, a comfortable home, and money in the bank they would choose that over having to drudge at a job that does not fulfill their intrinsic and ethereal desires.

Very few artists/creatives know how to professionally conduct and grow businesses. Very few truly understand that they themselves are the business. Most don't even really want to know how to run a business. Very often creators want to do what they've been placed on this earth to do. They are here to create. Business matters can get

in the way of creating. Whether it's the time it takes to learn and execute business or that it can take the creative out of the mindset to create and be a distraction and possibly a block.

Being responsible for mundane activities included in managing a business takes time away from the artist that could've been used for creating. Having to deal with negotiations, bookings, and/or commissions, event planning, paperwork, etc., might stifle creativity. A lot of us artists are fickle as it is. We should be allowed to simply focus on our art and not have to worry about where our next meal is coming from or when we will be able to get off of someone's couch and get our own place. To do that you have to have the business part handled. Often asking an artist to also run a business is like asking a doctor to practice law.

I have been a full-time artist/creative for five years as of the writing of this book. I realize that isn't the longest time frame in the world, but I have been able to help several other artists, from painters to poets to photographers, do the same in that same time span.

Before I was able to make the transition into choosing which projects I wanted to do and creating income-producing opportunities for myself I, like most people, worked a regular job. While I didn't love most of these jobs each one taught me a skill or a lesson that I utilize in some capacity in my dealings today. Each one contributed to me becoming the person that I am.

In order to be a full-time artist/creative means that you have to have a fairly consistent income sufficient enough to meet your financial obligations or exceed them. This would imply that you are selling your products or services. When this is the case there has to be some type of agreement reached between the creative and the consumer.

Even if the artist only sells one type of product and it is online, the artist and the consumer agreed on the price which is exhibited by the purchase of the item. If the consumer didn't agree on the price they would not have paid it. This does not mean that they loved the price but it does show that they were willing to pay it based upon its perceived value to them.

While a large number of artists/creatives would prefer not to handle the business part, other than the counting of the money, every artist should realize that it is a necessary element to their careers as professional artists/creatives. If you are not prepared to do the work then hire someone who is. Hire an artist manager, accountant, lawyer, and publicist because the work needs to be done by someone.

Steps need to be taken to professionalize and legitimize your business as an artist. Without having your business set up properly you will not be eligible for as many opportunities to produce income for yourself. Without having your business set up properly you leave yourself open to asset liability and double taxation. If you want your business to be taken seriously then you have to seriously start taking care of business.

In the art business, I have come across over one thousand artists at this point and most that I have spoken to would rather handle the art and leave the business to someone else. While getting someone else to do it is great I would strongly advise you to learn what it is that is needed to be done to ensure that what is being done is needed and accounted for.

Unfortunately in this world and more specifically the art/music world there are people who will take advantage of an artist/creative because they are brilliant creatives but they don't know the business. Very few have realized that as artists/creatives that they themselves are a product not only the products they produce. They themselves are a business.

In this book, you will receive tested advice and learn to use tools effectively enough so that if you do decide that becoming a full-time artrepreneur and quitting your day job is the path you want to take then you will be prepared for your journey.

I will use the words "artist" and "creative" interchangeably but mean the same thing. I like the word creative because it encompasses more talents and skills. Typically when people hear the word artist their imagination is limited to visual artists and those who make music.

While both the words "artist" and "creative" describe someone who makes anything that previously did not exist the word "artist" can limit the instances in which this can happen. For example, anyone who puts words on paper that was previously blank has

created something whether it be a speech, story, article, or anything else.

Anyone who concocts a joke and gets people to laugh has created something. Anyone who plans events and figures out the theme, decor, itinerary, menu, location, or anything else has brought something into existence that otherwise would not be there exactly as it is without them.

There is a long list of people that are considered creative including; Filmmakers, fashion designers, authors, graphic designers, artisans, architects, photographers, animators, chefs, web developers, dancers, curators, and even hairstylists are among many on the list. These are the people who this book is for. These are the people who make the world a beautiful place to live.

Contents

Introduction

To begin, it seems like a good idea to make sure that we are on the same page about our topic and what we are about to get into before we embark on our journey. I would not want you to get a third of the way into the book just to realize that its content added zero value to your life. I would hate it done to me so I will not do it to you. Just to clarify, this book has tons of value in it. Like all knowledge, it is all in the application. Unapplied knowledge is the fuel of fools. If you are looking for a book of cooking recipes then this book will have zero value for you. If you are looking to create for a living, you might want to laminate this book.

Historically there has always been a big disconnect between what you study, what your passion is, and how to turn that into something that can sustain you, where you can make a living doing what you love. We were pushed to go after what proved to pay consistent income and that our natural talents and abilities are only good for hobbies not careers. This problem has created its own solution, us: the artrepreneurs.

Before we talk about artrepreneurship, let us define what it is I mean and answer the question you might have asked yourself when you picked up this book. What is an artrepreneur? The word is an, hopefully obvious, combination of the words 'artist' and 'entrepreneur'. Artrepreneurs are at the crossroads of art, business, and innovation. They use business acumen and brand management to drive their creative process. Artrepreneurs combine the creative with the administrative. The entrepreneurial drive is the new energy behind the art.

Artists are realizing that traditional art career paths leave them at the mercy of collectors, gallerists, nepotism, and economic downturns. The successful artist now understands that while they still very much utilize these avenues they now have to create and control other platforms and revenue streams in order to thrive. Handing their products over to "gatekeepers" and others to do the work for them will seldom create a consistent and significant income stream.

New artists are having the longstanding problem of not being able to get a foot in the door. Art dealers and/or gallerists prefer artists and works that already have a history of selling. This brings about the conundrum; How can I get sales and or experience if no one will give me a chance to sell or get experience? Once the artist does get an "in" they might enter into business agreements and situations that are not in their best favor and might even be predatory because they lack the experience to know better and/or the guidance or mentorship of someone more experienced.

This book is about business just as much as it is about personal growth. When you are the business and the business grows you ultimately grow with it. The direction and activities of the business do not change unless you change, your mind at least. If your mind has changed, then indeed my friend, you have also changed.

This series, Tripping Over Canvases, really encompasses my journey into art, artistry, and art administration. I almost literally fell into it. If you read the first installation, "Tripping Over Canvases: How To Open Your Own Art Gallery With No Prior Experience", you

learned about my introduction into the art world. If you have not had the chance to read it yet make sure you do so, not for my personal story but for the knowledge offered on the art business side of being an artist owning your property and experiences.

For those who have read it and possibly forgotten I will give a brief refresher. For those who have not read it, I will give just enough back story to serve the points I will be making shortly. If you know me personally you know "I don't waste paint".

I do not have a formal education in art, art administration, art history, or any art-related studies. My Master's degree happens to be in public administration and outside of working art projects into public spaces to beauty areas, raise property values, and increase tourism and local business, the degree has little to do with what I do on a day-to-day basis as an award-winning art gallery owner.

My business partner and I had an epiphany, after being fired, to start our own business. That business was not originally an art gallery. At the time we knew very little about art other than that we liked it and understood and appreciated the skill and work put into creating such artwork. Having music production and artist management in our backgrounds made us familiar with the work required to produce a polished finished product but when it came to art we had no idea how to value it.

We came across a potential third business partner who was a gifted visual artist who pitched the idea that instead of a standard event space

we should consider opening a gallery. The idea of being able to utilize not only the floor space but also the wall space made great business sense to me and we proceeded on that path, unfortunately without the third partner but he's still like family to us to this day.

Once we already had everything in motion and our artistic partner dropped out of the equation we had a situation on our hands. We were in the process of opening an art gallery with no idea how to get people to come to see art, no idea how to find artists, no idea where to get art. We had the keys to the property and now we had bills. We had to figure some things out fast!

Prior to him leaving, my agreed-upon personal responsibility was mainly marketing, promotions, and obtaining sponsorships. The artist was to take care of anything art related. I had planned to just walk into the gallery and say, "Wow, that's nice" and maybe fold my arms and stare at it for a while in silence until someone noticed how smart I looked standing in front of a piece of art silent seemingly pondering universal mysteries for a time.

The solution: learn. I had to learn about art. Different types of art, different styles of art, different eras of art, different price points for art. My partner and I literally visited over fifteen galleries in roughly a two-month span including driving from New Jersey to North Carolina to see the grand opening of an art gallery of a quickly rising artist who was now transitioning to being self-employed as an artist full-time. She had turned herself into a business.

We soaked up so much information, made connections that we still utilize, and found mentors in the local art community that brought us into the fold like we were there the whole time they were. One of such mentors was the late Jerry Gant (Newark, NJ) who ran with and painted with Jean-Michel Basquiat and was around when he met Andy Warhol and even accompanied him a few times working with Warhol.

We opened our gallery Above Art Studios in 2016 and since then have housed almost 1,000 different works from over 100 artists from multiple countries. I have personally published two e-books before publishing my first paperback (had to warm up). I am on the advisory board for the New Jersey Art Administrators of Color, consult for local art counsels, and have worked with the Rutgers University Art Department and the Zimmerli Museum amongst other things.

The knowledge that I have obtained first-hand becoming both a full-time artist (painter, instructor, poet, writer) and also an art administrator (art director, gallerist, project manager, curator, panelist, mentor) has helped me just as much, if not more than any MFA program or arts administration degree could have.

I compiled that knowledge into this book you are reading. You get a step-by-step process of how I got things done, the people whom I talked to, the things that I said, the issues that arise, and the solutions to the problems. The phrase, "it costs to be the boss" is very real. I paid my tuition in the real world through my mistakes and miscalculations and learned on my own dime. Everything I did wrong is permanently etched

into my banking history. In this book, you get all of the wins and you learn how to avoid the losses.

During my journey, I have been asked an innumerable amount of times how I have accomplished what I have accomplished, how I have been invited into the circles I now associate with, and how I am consistently able to make my vision physically manifest. The conversations tend to be so energetic and always splinter off into so many different directions that I am never able to get it all out. Hence, this book you are reading. If I don't get asked any questions while telling a story or don't get asked to further breakdown a point when that one point was one of many to begin with it is easier to deliver the most helpful and relevant information to assist you in reaching your goals.

There are many myths, miscalculations, and misconceptions about the art business that are perpetuated by artists, gallerists, and collectors. There are plenty of reasons to believe being a full-time artist isn't feasible or comfortable, let alone luxurious living that you will find if you look for them but there is also evidence that it can be. Sorry to be cliche but… it's all about what you make it.

This book gives me an opportunity to disseminate concentrated organized information. It will be as in my first book, *"Tripping Over Canvases: How To Open Your Own Art Gallery With No Prior Experience"* in that it is also clear and concise with no fluff or cushion. All suggestions will be mapped out and actionable, not just theories of what could possibly work.

I have met many aspiring artists, artists who have been doing it for a while but are not making money, artists who make money from time to time but want to become full-time artists, people who love art and bringing artists together, and people who want to spread art and give artists opportunities to create and thrive.

In order to get to the next level in the art business you have to realize that the phrase consists of two words; art and business. Most of you reading can produce or know where to find the art. that is great. As a creative, if you're like me, you rather not be bothered with the other side of things. This is the business side of the art business.

"Art has no compromise—with anything, anybody, any process. But once the art is done, it is a business. You have to do your taxes. You have to know how much you spend on rent, supplies, and materials. There's always a cost involved," (Julio Valdez, JVS Project Space).

Artists are typically curious and can see possibilities everywhere. Monetizing curiosity, however, can be a daunting task. Creating a sustainable life in the arts is complicated. I have done it and helped others do the same. Let me help you.

This book will help you handle your art like a business so that you can have an art business! If you do not handle your business then you will never have or soon no longer have a business to handle. Thank you for purchasing this book, believing in me, and investing in yourself. I am a firm believer in 'each-one-teach-one'.

The better you get at bringing art into the world the better the world gets. The better we get at handling our business the better the artists get compensated for bettering the world! I hope that we can do beautiful business together one day and create a masterpiece like one of the many we see from the talented artists we encounter. Becoming a professional artist takes a lot of work but, if you do it right, it doesn't have to take a lot of time. Now let's get down to business. Open your computer and grab a pen and paper.

You Are A Business

"I'm not a businessman. I'm a business, man.", (Jay-Z, Diamonds Are Forever)

We will talk about starting a business. I mean formally filing paperwork with your state of residence to incorporate but I want to inform and emphasize that you already are a business. If you can produce goods/products you, yourself, are already a business. Even if you are "the idea guy" you not only have intellectual property, you are intellectual property. You are a business because you can produce more ideas. You are not just in business. You are the business!

"You might not think of it this way, but as an artist, you are the owner of a small business, just as I am. As the owner of your fine art business, you have to manage your accounting, your inventory, and your marketing. You have to find time to build and maintain relationships with galleries. If you sell your own work, you have to manage your sales, both by making sure that you are developing new leads and following up and closing sales. You are responsible for managing your website and following through with your social media. These tasks alone could keep you busy most days, and we haven't even mentioned your most important work: creating art," (Jason Horejs, Xanadu Gallery).

Your talents/abilities/skills have the potential to splinter off into many different directions, all of which can bring you more success and wealth. These potential businesses only exist if you exist. They only work

in that specific capacity if you are involved. Someone else can have similar talents and abilities but only you can do it exactly the way you do it.

That being said, now that you realize that you are a business you have to conduct yourself accordingly. I am not saying that you absolutely have to restrict yourself or portray an image to the public that is in contrast to who you truly are. I am saying that people will not only judge you, be it wrong or right, but they will now also be judging your business(es).

If someone needs someone professional to use for their business they will call on those who are known to be or at least present themselves as professional. If you are known for being a clown you will only get calls when there's funny business (pun intended). No one calls a clown for serious business.

Your reputation can cause you potential partnerships and opportunities if you do not nurture it. A potential partner might not want to work with you in linking with larger companies if being professionally attached to you makes them look amateur and unprofessional. I even have artists that I hire to instruct classes and/or that I pass commissions to because I am busy on the administrative side and I also like to spread the wealth and opportunity but I will not call certain artists to be in certain environments or deal with specific types of customers because it just isn't a good fit. The person might not be professional enough and, in turn, make me and my organization look

less professional which can lead to fewer referrals and future business. Don't be that guy/girl!

As a creative myself, I understand the desire to simply create. I too often want to just produce and let it go into the world. The problem with only doing that is that, often, very little of the world gets to see it, and also the world doesn't send me checks or direct deposits. If you truly do not want to, under any circumstances, handle the business portion then you absolutely have to find someone who is willing to handle it for you, whether they be for-hire or for free, you need them!

You have to find your own unique way to combine your propensity for and love of creating with your passion to share your gifts and ability to make money. There are many roads to the same destination, but on every journey, you're going to need to eat.

No one is asking you to stop creating but I am asking you to teach yourself new skills and/or hone the business skills you already possess. Learn how to communicate and also the psychology of sales. You will be selling your products and/or services so sales skills will come in handy. If you do not know how to sell often people will not know how to buy.

There will be times when people just walk into a venue, see your art and walk over to you, money in hand. That will not be most of the time! Most of the time work and salesmanship will be required. You will have to go into business mode and conduct business if you want to remain in business. Treat it as such and that is what it will be.

At least twenty-five percent of your time has to be directed to the business portion of your art business. The creative side should not take more than seventy-five percent. I understand you have to create a product in order to have a product to sell but you have to look at it as inventory. If your inventory is full you cannot house any more inventory not to mention you have money/resources tied up in that inventory that has not yet been recouped.

Once you have a solid body of work already compiled you will quickly discover that if you do not spend time selling your pieces then you will eventually run out of space to house them. Selling helps fuel creation, not to mention it finances it too. Don't be afraid to sell. If you are afraid to kiss you will move your head when someone tries to kiss you and you will miss all of that sweetness. Don't wait to be kissed. If you see their lips puckering go for it (metaphorically).

Most galleries would prefer you create a strong brand and stick with that. I, as a gallerist, understand. It makes it easier to pair those works with buyers if I have an idea of what type of work will be produced and the people that fancy that type of work. As an artist, I do not like being restricted to what I can and cannot do. Being that you are a business yourself you have to determine what works better for you.

An easy middle ground might be to create a sub-category of the category you have become known for. If it's not too far from what your collectors already have but shows growth and new promise it will make it easier for all parties involved. Artists can now represent themselves because of the internet and although it is a great opportunity to be placed

in front of people who have been proved to appreciate and invest in art it isn't as necessary to be exhibited in a formal gallery as it was years ago. If you are a beginning or mid-career artist I would definitely still recommend that you seek gallery representation as part of your strategy.

As with any career, your succession will happen in stages and/or levels. You will most likely not become a sought after international selling artist overnight. It is very important to focus on how you start. How you start plays a large part in how you finish. Now that you understand that you yourself are a business, let us get our business affairs in order starting with how we structure our business.

The Structure

It has been my experience, I have spoken with many artists and I also did this myself before I knew better, that most artists have not set up a formal business structure through filing with the state they live and/or do business in. When they get paid in tenders other than cash or a cash transfer via an app those funds are tracked by the IRS and attached to the artist's social security number. The artist is then responsible to pay taxes on that income. Not filing as a business and receiving an EIN number means that there are fewer items that you can write-off as business expenses against your earnings and also that you are not protected and are liable to lawsuits and/or whatever other debts or problems your business has.

Not having your business set up can hinder you from opportunities to work with organizations that outsource companies for services that

you can provide. Some organizations, namely academic institutions, only work with companies, not individuals. Although technically your company is just you, it's all about the structure. Even if you decide not to set up an LLC (limited liability company) at least set up a DBA (doing business as) and get an EIN, it is free of charge.

With an EIN you can open up a business account. A business account will allow you to avoid commingling funds from the business with your personal, non-business funds. This is an important step because with an EIN, a business bank account, physical address (you can rent a physical address, more on that later), and business phone number you can start to build your business credit.

Business credit can be used to purchase more supplies to create more work. As artists, especially starving artists, we might struggle to buy supplies that could be sold for money. We might sell a piece or get hired to perform but that money has to go to living expenses so there is nothing remaining to reinvest into the business. Business credit can be the solution until you get ahead of the game.

Business credit is especially valuable if the artist does not have good or established credit themselves. In fact, there are ways for an artist with bad credit to still be approved for and be able to build business credit despite their credit score.

LLC

Your first thought when beginning to think about forming your business might be to go with a Sole-Proprietorship. This thinking is

logical considering it will most likely be you and only you create your pieces, be it poetry, art, or otherwise, so it would make sense to set it up solely based on you. If you did decide to formally hire employees, at some point in the future, you are responsible for changing the legal structure of your business to reflect that change.

While the Sole Proprietorship is the simplest and most popular form of business start-up, it may not provide entrepreneurs with the legal and tax advantages that an LLC does. It costs nothing to establish a sole proprietorship. If you have a business partner or any type of partnership this is not an option for you, unless they happen to be silent partners and you have previously worked out any equity sharing arrangement beforehand.

As a sole proprietor, you report the net income or loss from a business on the "proprietor's" (business owners) personal income tax. Generally, sole proprietors own small or part-time businesses with no employees. You can be a single-member LLC so you get the benefits of not having to listen to anyone else along with the protection it comes with.

Unlike a sole proprietorship, an LLC is a hybrid of the partnership and corporate forms that allows the liability protection of a corporation with the tax advantages of a partnership.

One of the key benefits of an LLC versus the sole proprietorship is that a member's liability is limited to the amount of their investment in the LLC. Therefore, a member is not personally liable for the debts of

the LLC. A sole proprietor would be liable for the debts incurred by the business. Creditors can go after a sole proprietor's home, car, and other personal property to satisfy debts.

If you are planning to be a sole proprietor, you should first establish a D.B.A. ("doing business as") with the county clerk's office near you. This D.B.A. ensures that no one else is doing business under your name or your business name in the county, and enables you to open bank accounts, apply for credit cards and small business loans, and other vital business services under your assumed name.

Non-Profit

If you have the means, I recommend starting a non-profit or at least a non-profit arm of your business to mirror the original business. Being a non-profit allows you to receive a lot more grants that are available to creatives. Not having this classification means that you are missing out on money that has to be spent by the end of every fiscal year.

A lot of people hear the term "non-profit" and they automatically believe that this means that they are not allowed to be profitable. This is far from the truth. In fact, the National Football League (yes, the NFL) is a non-profit organization and I assure you they make tons of money. The only thing that you are required to do is reinvest those funds back into the business to help achieve your goal/mission. This reinvestment can include hiring staff and/or justifiably increasing salaries (paying yourself more).

A for-profit can raise money from private investors, for which it must give equity or dividends to shareholders; ultimately, a return on investment is expected. A nonprofit, on the other hand, can seek donations from individuals, foundations, and also corporations. These stakeholders generally expect a "social return" on capital.

If you take my suggestion of having both a for-profit business and a non-profit arm you could simultaneously raise funds through grants and philanthropic contributions while you also raise money from venture capitalists or your grandmother if she wants to invest with you. Granny might want to see her money flipped so work that out before you accept it from her and ruin the relationship.

Business Credit

So, we touched a little bit on business credit earlier and some of the benefits that having established business credit can provide. The next question is the part that a lot of people, even those with excellent personal credit, often are not familiar with. How do you establish business credit?

If you are anything like the average artist who has been attempting to be a full-time artist you have experienced times when the funds were not flowing rapidly enough in your direction. At these times you might have borrowed from friends/family and even taken out personal loans, charged up credit cards, or fell behind on your car note. Your personal credit might not be healthy enough to stand as the personal guarantor for your business to get lines of credit. What do you do?

I am not a credit expert but I have personally used the following to build up credit for my art gallery business and just began the process again for my consulting business. You do have to do these steps in order and it does take some time as you have to wait for your creditors to report to the effective credit agencies (either Equifax Small Business, Experian Business, and/or Dun & Bradstreet). All creditors do not report to every credit agency so how your credit rises depends on which credit accounts you ultimately open. Follow and trust the process. If you do not follow the steps in order you will not get the same results.

Business Credit Building Steps

1. Incorporate your business

2. Obtain EIN

3. Open business bank account

4. Get business phone number, email, and website

5. Register company name and number with national directory (411)

6. Get a Duns number (www.dnb.com)

7. Get 3-5 Net30 accounts (www.quill.com, www.grainger.com, www.uline.com)

8. Use paying your business expenses to help reporting to credit agencies, i.e., cell phone, internet, utilities (www.businesscreditbuilderservices.com)

9. After 3 months of payment history with the Net30 accounts open gas cards

10. After 3 months of payment history open store cards (Home Depot, Amazon, Kohls, Michaels, etc.)

11. After 3 months payment history open major credit card and/or line of credit

Market Madness

Now that the internet and social media have leveled the playing field and there are very few remaining gatekeepers into the world of professional creativity it is possible for anyone to achieve their dreams. It is possible but only becomes highly probable when we are taking appropriate steps in controlling our business.

Sales and Marketing are two different departments respectfully because they are two different beasts but they go hand-in-hand. It is difficult to generate sales without knowing who to sell to and you can have a lot of people willing to purchase a product or service but if you do not have anything to sell them or the techniques in which to stimulate their impulses it makes no difference. If you are hard-working, pragmatic, organized, and positive, you will find opportunities to sell your work but you have to have at least some semblance of a plan.

At its basic level, art marketing is a systematized process of creating awareness and interest for an artist or artwork that leads to a desire to engage the artist, gallery, or company, to own its products, use its services, or all of the above. Marketing can be complicated and sophisticated requiring a lot of knowledge, experience, and continued learning.

What you are going to need are the desire to be successful, the willingness to be uncomfortable enough to grow, the ability to apply relatively easy-to-use marketing tools, and the organizational skills to

accomplish simple, practical marketing plans. On the business side, your art career success is about identifying your target audience or customer, clarifying your goals and your strengths, and discovering the best marketing methods to use for your specific situation.

No matter how wonderful, beautiful, or masterful your art is, if no one sees or hears it then it does not matter. Yes, we know a tree that falls in the woods makes a sound whether or not someone is there to hear it but we also know that a painting on a wall of an art gallery and no one is there to see, does not sell. I'm sure, like me, you have witnessed terrible products with great marketing that do well and in some cases even better than higher quality products.

If you are struggling as an artist it does not necessarily mean that you are a bad artist, especially because I have seen bad art sell. It could most definitely be an indication that you are bad at marketing. You might want to consider either hiring someone good at marketing or becoming good at it yourself. I recommend the latter even if you do hire someone. That way you know what to expect and can better oversee the process to maximize effectiveness. You do not have a business unless you have a successful marketing strategy.

Choose Your Market

Everyone might need some form of transportation. That being said, selling a car, even a dream car, to a person without any hands or feet might prove unnecessarily difficult. Even though they might appreciate

the aesthetic they have little use for it thus it loses value to them personally.

We have to learn to try to sell that vehicle to someone already in the market shopping for a vehicle. We find higher rates of success when we can gather up everyone who is looking for a four-door mid-sized vehicle and that happens to be exactly what we have to sell.

In the automobile sales industry, we had a saying that went "there is a butt for every seat". While I witnessed this proven true many times over as cars moved off the lot that I imagined no one ever would purchase I learned a lesson. Yes, someone might eventually stumble across your work and want to purchase it but do you have space and time to let it sit there for years potentially to wait for it to happen?

You can't sell a Bently to someone in the market for a Kia (not saying your art is a Kia). It would be more efficient to market a lime green 2 door hatchback in a group of people who already have similar vehicles and/or who gather for events where those types of vehicles are featured, i.e. niche car groups and car shows. You should do the same with your art.

Do what you do and look for people who already do something similar and discover who likes/follows/supports them. The saying "there is nothing new under the sun" rings true in most cases. There are over seven billion people on Earth as this is being written. The likelihood that you will do something never before done is minuscule. There is someone either alive or dead that is doing or has done something at least similar

to what you are doing. Find the people that like those people. They will most likely like your work as well.

Social media and the internet have made it easier to find people that have similar interests to you. We are now able to connect with people with like minds and/or tastes that may be thousands of miles away from our physical location and not have that distance be a definite hindrance. The word "local" can now mean a different thing than it did a decade ago. It can now refer to people we have ready access to despite logistics. Once we have become acquainted with someone they can now be a part of our "local" art community.

I know what I just wrote. Trust me, I read it twice. I just want to make it clear that I am not telling you to sit on your thumbs or your computer all day and not physically or virtually meet people in your area. You need to get to know people and let them get to know you, or a piece of you at least. If people feel they know you they can discern whether they like you or not. People tend to buy more from people they like. If they like you they will buy from you at some point. Even if it is just a print or even a button to support.

The next most accessible group of people to sell your art are those who know somebody who knows you. Or, they learn something about you because you used a celebrity or well-known individual to get some local recognition. Marketing like this gives you the hometown advantage. If you are not using these strategies to sell your art, you are ceding the business to someone else and making your art more expensive to sell because your only prospects are total strangers. Start marketing

locally at first and then reach further away from your physical location once you have established yourself enough to receive good feedback when someone researches you and/or you have earned enough to finance the larger marketing plan through sales made while marketing locally.

If you ignore the potential customer base in your backyard while spending time and effort trying to develop a following far away from home, you have your marketing turned inside out. Your marketing should be concentric by drawing a radius around your hometown to start your marketing.

You know people, yes. You may not know a lot of people but the people you know also know other people and that replicates and gives you access, in theory, to more people than you personally are acquainted with. Start from where you are and who you know and work from there.

First, identify your target with clear intentions on what you need. Then begin to work on how to achieve your goal. You start by asking people who you think are the best prospects for knowing someone who might know someone. When you ask, have a stated purpose in mind. In most cases, you also will want to ask how you can help the person whose support you are trying to recruit. By offering mutual aid, you are going to have higher results than by merely asking. In other words, by having a specific reason to talk to the person, it is easier for you both to determine whether or not that person can be of assistance or maybe point you to the person(s) than can.

Meeting for no specific reason is very open-ended and gives no measure of how much time and energy you are asking for versus, for example, you just wanted to meet them about a specific reason, they could come to the conversation prepared to help you. I have more than one mentee myself and my personal response to a request to speak about a specific subject or area of interest is much more enthusiastic versus someone asking me if we can "talk or chop it up when I have a chance". About what, I ask. "Nothing in particular. I just want to pick your brain." Ouch! That sounds painful in more than one way. I am not saying to limit yourself to only those questions you have immediately. Most of the time questions lead to more questions which is fine but have a plan of action. Do not go in asking for random hours of their lives which they might see as wasting their time.

Marketing is Not Selling

They now know it exists but that does not mean it's sold. Sales take place only after art marketing has done its job to create attention, interest, and desire to own the work. You instinctively know you cannot build a career on spontaneous art sales. Most art, especially originals, requires repeat exposure to your prospective buyers before attention, interest, and desire can lead to a purchase.

For most people, art is not a necessity. Desire, nostalgia, and/or beauty often are still not enough to persuade a customer to buy art. More consumers are becoming more practical with purchases. Uncovering and responding to objections, presenting alternatives, providing reassurance, simply asking for the sale, and other factors are all instrumental in

creating art sales. Your art marketing may lead them to the gallery, studio, or website but the interaction and follow-up that takes place after that is where your ability to sell comes front and center.

Sales and marketing are two very significant, but different, functions within a business or organization. Simply put, marketing involves laying the groundwork for the sales process. That includes attracting leads and prospects to your business. Sales, on the other hand, involves closing the deal once they have discovered your business.

Although the sales process is often thought of as the conversation that helps people determine whether or not they will buy from you, there's a lot more to it than that. It includes all of the actions that are necessary to sell your company's product or service including; contacting the lead, determining the prospect's needs, pricing products and services, preparing proposals or quotes, etc.

Marketing informs people about your business, educating them about how the product or service you offer meets their needs or wants. Marketing researches target audiences, what those audiences need, and how the company's products or services best meet those needs.

One of the quickest ways to explain the difference between sales and marketing is to show the different strategies taken to achieve their goals. Below is an example:

	Marketing	Sales
Strategy	Online	Value Proposition

	Print	Conceptual
	Email	Solution
	Social Media	Benefits
	Video	Inbound

Branding

Where marketing ends, branding begins. They are not the same! Mixing up marketing and branding is only one of the most common misconceptions about branding that you will encounter. Marketing, advertising, and other promotional activities only communicate your brand personality and your message. Your brand comprises your personality, your voice, and your message; branding is the process of establishing these traits.

In establishing your brand, much like your personal reputation, you will discover that the image, messages, and/or persona you wish to exude might not be exactly in line with how people are perceiving you or the brand. Your customers are the ones who ultimately define your brand. Their perception of your brand is what sticks with the people they influence. This is why it's very important to select your brand values carefully; otherwise, your brand may be taken the wrong way – or worse, it may fail when you don't see repeat customers. And yes, it still might happen regardless but best to take whatever precautions you can to lessen the likelihood of that happening.

Because your business had a unique identity and needs it is imperative that you find what works for your business explicitly. While

a similar strategy for a similar business might have some things figured out it is good to use but be sure to adapt it to your business specifically. Branding is and always will be a customized experience.

Establish Your Purpose

The first thing you need to clarify is why you do what you do. You won't get the answers right away – you'll need to ask yourself why several times before you get to the root purpose, the very core of your business. Start with questions like:

- Why did I build this business?
- Why do I want to help out this specific group of people?
- Why does it matter to me that these things get done?

As you keep going, note the answers you are giving each "why" – these answers will form your purpose.

Choose Your Personality and Voice

After asking why you do what you do, ask yourself: What is my brand? This will help begin to shape your brand, becoming a skeleton on which you will attach the rest of the ideas, values, and messages. At this stage of brand building, ask yourself the following:

- What kind of voice do I want to use for my brand?
- How do I want to be perceived – do I want to be approachable and casual, corporate and formal, etc.?

- Will I be able to stay true to this identity throughout the existence of this brand?

The last question is specifically important because your audiences will be looking for a solid, consistent identity. Your ability to stay true to your brand is one of the most important elements that will earn you customer loyalty.

Outline Your Values

Once you finish asking yourself what you are, it's time to ask yourself "Who am I?" The values that you get from the previous step will define who you are as a brand. Write these down and define these values concerning your business.

Fashion Nova does a great job of outlining and defining its values. They have ten core values that they live by, and if you go through their blogs and their website, you'll see these values imbue every process they have. You'll also notice the people following these values to heart, from the blog posts to their performance, to their customer service. Defining a good, solid set of values will help you become consistent and serve as your company's guiding principles for work.

Define Your Culture

Your integrity as an organization depends heavily on the culture you cultivate in your business. Happy employees are productive, passionate, and cohesive, making your business stronger and your processes more

easily manageable. This is why it's important to establish what kind of culture you want to nurture in your establishment.

Google's culture is very famous for encouraging creativity and innovation by giving their employees time and resources to explore new things. Their 80/20 policy had paved the way for innovations like Google Glass and Android. Although it is not being implemented as a policy anymore, their engineers are still encouraged to take on side projects that allow them to innovate. You can see how the culture lives on despite the fact that the policy has been removed – that's the power of culture.

Communicate Your Brand to Your Audience

Finally, you get to the point where marketing comes in – you now have to decide how you want to raise awareness about your brand. The previous steps, combined with market research and analysis, will play a huge role in determining how and where you communicate your brand to reach your target audience effectively.

The following will be the most important points to discuss when planning communication strategies:

- Your company's mission statement, which you can easily derive from your purpose;
- The benefits your customers will get from your business, which is also answered at the beginning of this process (the answers to the why's)
- Your chosen platforms and the appropriate media for each

- Your calls to action – what goals do you have, and how do you plan to entice your audience?

Conclusion

Branding isn't the same as marketing – branding is the core of your marketing strategy. In order to build an effective brand, you need authenticity and clarity in each of the steps discussed earlier, allowing your target market to identify with your brand personality and values successfully.

One final thing to remember – and a very important point – is that branding isn't a one-time thing that you do at the beginning of establishing your business. It is an ongoing effort that permeates your processes, your culture, and your development as a business, and it requires your dedication and loyalty in order to reflect in your work. At the end of the day, the true measure of your branding success is in earning loyal customers who become your brand ambassadors because they love you and what you do.

The Mentor Ship

If you are like most people on planet earth you have had the thought or even uttered the phrase "If only I knew back then what I know now". Now, while we can't rewind time and also allow you to keep the wisdom that you gained by living life to go with you into your younger self, we can find someone to pass wisdom onto you that they have garnered from either living longer than you or from having been doing what you're doing longer than you've been doing it.

We are talking about mentors. By definition, we mean an experienced and trusted advisor. Mentorship is a relationship in which a more experienced or more knowledgeable person helps to guide a less experienced or less knowledgeable person. The mentor may be older or younger than the person being mentored, but they must have a certain area of expertise.

I am a strong advocate for mentorship as I believe that life is way too short to make all the mistakes yourself. .If you can try to get a mentor in every area of your life. Get a mentor for business, a mentor for health, a mentor for relationships, etc. Shortening your learning curve and learning from the successes and failures of others will always be worth your time, even if it's figuring out what not to do.

Mentoring is important, not only because of the knowledge and skills you can learn from mentors but also because mentoring provides professional socialization and personal support to facilitate success.

Quality mentoring greatly enhances your chances for sustainability. The most beautiful thing about mentorship is that it is most often FREE!

A mentorship works much like an agreement. The level of formality depends on your desired outcomes. When you've taken the time to decide who you'd like to have in this role, schedule a discussion with your mentor to work out any agreement details. Knowing how much time this person plans to invest in mentoring you helps guide future meetings.

Informal mentorships may involve calls, texts, or emails to your mentor when you need guidance. Formal mentorships may have a defined schedule that details the specific dates and times you plan to meet. What you choose depends on your unique situation.

Mentors look for ways to encourage personal growth. Once they understand your skills and abilities, they may put you to work on a specific task to see how well you perform. Based on your performance, they might give you another challenge to test you or give you detailed feedback on what you did well and what you may improve upon. Mentors look for teaching moments that help you grow along the way. Mentors can see where we need to improve where we often cannot.

I experienced a lot of tough love from my mentors. They did this because they understood that being an entrepreneur can be challenging when it comes to self-motivation and self-discipline. They took on this role of parent to teach me good work habits and provided the boundaries for me to work within. This solidified my work ethic, sharpened my

focus, (I really missed some important essentials), and clarified my priorities in a way that I could not do on my own.

They provide ideas, thoughts, and insights that challenge you and enable you to see beyond your sphere of influence. Mentors amplify visions by elevating your thinking capabilities. Mentors elevate you by making their shoulders your platform. They prop you up and this demonstration of trust must not be abused as their extensions are a critical validation that will eventually open doors and grant you access to opportunities beyond your current circle.

In short, mentors provide undeniable counsel and resources that are not necessarily or readily available or accessible. One of the key realities on life's journey is the fact that no one can 'do,' or 'go' or 'be' without others. In life, we need others, and others will need you as well.

How to find mentors

Now that you understand some of the many benefits that having quality mentors can give, we can move on to the next question. How do I find a mentor? That's a good question. Thanks for asking.

The easiest way to find someone who has experience doing what you are doing or want to do is to go where they are or where people gather who do that what it is that you do. Did that make sense? Ok, let me break it down. If you want to learn how to skateboard, hang out at skateparks, and see who does better tricks than you. If you want to learn how to dance, visit some dance crew battles, (yes, those are a thing). If you want to be a full-time artist, find some other full-time artists and

make nice. They will be at exhibitions, galleries, art battles, mural revealing, etc. If you are not in a certain area or are having difficulty finding the mentors you need you can also use www.score.org and www.mentorcloud.com as resources.

If you cannot find any physical mentors right away do not fret. There is still a ton of information available from reliable resources that can help you in the same way. Actually, according to Michael Hyatt & Co., there are eight different levels of mentorship, and finding an actual personal mentor is the highest level on the list. Here is what they list as the eight levels;

1. Blogs and podcasts. If you could wave a magic wand and be mentored by anyone, who would it be? John Maxwell, Dr. Boyce Watkins, Earn Your Leisure Podcast, Dave Ramsey, all the above or someone else? They have a blog or podcast or Youtube videos and are already churning out a ton of content—for free. Are you taking advantage of it?

2. Books. There's no greater tool than a timely, relevant, and well-written book. For less than $20 (most of the time), you can get someone's best thinking on a specific topic. Never before in history has so much knowledge been available to so many, for so little. If you do not have the time, patience, and/or discipline to read a book then audiobooks are a great option, especially if you spend an ample amount of time on the road. You can listen in your vehicle. And if you don't have the money to buy a book, go to the library.

3. Courses. I've spent hundreds of hours with Tony Robbins, David Shands, David Allen, Alfred Edmond Jr., and numerous others. Not all personally, of course, but by taking their courses. This is the next level up from reading a book. The instruction is more in-depth and, as a result, more likely to actually transform my behavior.

4. Conferences. Whenever possible, I prefer live instruction. It provides an opportunity for total immersion, focused learning, and interaction with other attendees. It occasionally provides direct access to the instructor(s). I make it a priority to attend three to four conferences a year as a student.

5. Masterminds. I first heard about these while listening to an audiobook, *Think and Grow Rich, by Napoleon Hill.* I attempted to form my own and only found a handful of people I wanted to interact with that understood what it was I was trying to do. It seemed like a new idea to most people a few years ago and there was a reluctance to try it. Now they are all the rage. They are actually a very old idea. It's a wonderful opportunity for peer mentoring.

6. Membership Sites. This can be a wonderful hybrid of input from specific mentors plus the input of fellow members. For many people, this is the perfect combination. You can bounce ideas not just off of your mentor but the community as well.

7. Coaches. If you are willing to pay for a mentor, a coach is a great option. While you may think you can't afford one, I would challenge you to investigate it before dismissing it. If a coach

helps you seize one opportunity, optimize your productivity, or avoid one fatal mistake, it will pay for itself many times over.

8. Mentors. Though a true mentor may be difficult to find, it's not impossible. If you have one in mind, start by building the relationship—just like you would anyone else. Don't lead with "Will you be my mentor?" (That's like asking someone to marry you on the first date.) Instead, get to know them. Look for opportunities to be generous. See how you can possibly add value to them too. Start small and see where it goes.

Now that you have found at least one mentor, what's next? What do you do? What is the best way to contact them? When do you contact them? How many mentors do you need? How often do you contact them? What do you ask? How do you not become a burden? How do you grow the relationship? It is important to be prepared when meeting with or communicating with your mentor? These are a few of many questions that will arise and though I will not touch on them all I will give you some questions to ask them.

Being prepared brings with it professionalism and efficiency and it shows not only that you are organized and focused but that you also respect the mentor's time that they have given you by not wasting it fumbling and mumbling. You also do not want to have a whole interaction or exchange with your mentor just to realize afterward that you forgot to ask so many important questions. These are a few to get you started and the conversations should naturally spin-off from the answer to each question creating subsequent questions.

Questions to ask your mentor

1. How did you get into your career?

Mentors are typically in a more advanced position on a career path similar to yours. As a result, understanding your mentor's journey may help you refine your own professional path. You can learn the typical steps in this profession, including education and early jobs, and what you need to achieve at each level of advancement. Perhaps your mentor pursued opportunities outside of the typical career path that provided many benefits. Your mentor's professional journey can serve as an outline to follow or provide you options you had not considered or, at the very least, inform you as to what to steer clear of.

2. What is an obstacle you encountered, and how did you handle it?

Overcoming obstacles is essential to succeed in any career. Virtually no one made it without any setbacks, detours, or milestones they had to meet before achieving success. Your mentor has likely faced challenges similar to those that you may encounter in your own career path. You can use your mentor's experiences to help you anticipate issues and prepare your own response. Ask your mentor how they feel about the results of their reactions to obstacles and what steps they took to remain focused on their goal in the face of setbacks. You can learn from their successes or discover ways they would handle the situation better had they known then what they do now.

3. What career accomplishment are you most proud of?

Career accomplishments can include earning promotions or subtle successes such as conquering a small but complicated issue. Consider discussing the accomplishments that gave your mentor the greatest sense of pride to help you establish your own career goals. Your mentor's perspective on career accomplishments can encourage you to value improvement as well as measurable success.

4. Have you read any books that helped you develop your career?

There could be many resources that helped your mentor on their professional journey, from fictional works with valuable messages to non-fiction books on productivity or leadership. This question can lead you to a variety of literary works filled with information and inspiration for your professional journey. Discover what books your mentor has learned the most from, and make a point of reading these books yourself. They may also be able to provide you with other helpful resources such as documentaries, podcasts, online interviews or presentations, and more.

5. What do you see as my strengths?

Understanding the skills you excel in can help you identify the professional opportunities that are best suited to your talents. Your mentor can help you assess your strengths objectively, providing you a list of skills you can mention on your resume or use during your next job search. You can use your mentor's assessment to answer interview questions about your strengths, including examples that demonstrate how you use your strengths to complete tasks and achieve goals.

6. What areas can I improve in?

You can advance your career by improving areas that could be more developed, but you may not be able to see your own weaknesses clearly and objectively. Seek your mentor's guidance on career-related skills you should improve. Your mentor may be able to help you find resources such as continuing education, additional training, that or potential practice opportunities.

7. How am I viewed by others?

Mentors can help you see yourself as others see you and to understand where your skills and talents are most appreciated. If your mentor works in the same company, they can give you an idea of how your coworkers or managers perceive you. A mentor from a different company may have insights on your overall reputation within your industry. This information can help you build on your strengths and address areas where you'd like to change others' perceptions of you for the better.

8. How can I prepare for my performance review?

Performance reviews are annual meetings with your supervisor or employer that reward your success and encourage your improvement. Your mentor can provide insights into what to expect during your performance review, especially if you are in the same company. They can also offer advice on responding tactfully to the feedback you receive. You may try role-playing important interactions during this meeting, such as taking criticism or asking for a raise. Performance reviews help you set

goals for improvement within your company, so preparing with your mentor for these meetings can ensure you stay on your intended career path.

9. What is your leadership style?

Effective leadership skills are essential if you'd like to advance into a management role. Discover what philosophies your mentor finds useful and how these have impacted their ability to successfully lead others. You may choose to utilize these leadership techniques or adapt them to your own style.

10. Do you think you could have done anything else and become just as or even more successful?

A lot of people with talent often have more than one talent. Finding out what other avenues might have been an option for certain talents could help you decide which talent you want to focus on yourself.

Become a mentor yourself

I am not sure who said it but I know I heard it somewhere, "The best way to learn is to teach". Having people ask you questions can inspire some questions of your own which you can ask your mentor later. Mentoring gives you the chance to engage with someone younger than you, who may see things very differently. In a changing world, it is essential to understand how those who have come after you think, and also how they view your own generation.

We all get into bad habits, whether professionally or personally. A different point of view can help you understand why you take a certain course of action, or why you think in a certain way.

As you pass on your advice and experience, you will have a better idea of how well you are living your own life. Learning how to work with people to whom you don't have a natural connection, demonstrating patience with those in need of guidance and support, helping people figure out the best path forward are all trademarks of a great leader and these skills are best honed through mentoring.

Mentoring is a unique opportunity to step outside your normal circle of friends to gain an intimate understanding of how the world looks through someone else's eyes. New perspectives often lead to fresh ideas, and who knows where fresh ideas could lead? What better way to stay in the loop and keep your finger on the pulse than to be in the minds of the younger people changing the world, or at least, the way the world works?

Produce & Profit

You can be one of the most prolific creatives in the history of the world. People from all walks of life could absolutely love your creative works and long to possess them for themselves. The problem is that they cannot buy them if they do not exist. If you are not producing work or driving traffic to the work you already have then you are not producing income. If you have no product to sell then you have no sales, simple math.

One of the pitfalls of being self-employed and having the ability to make your own schedule is that you have the option to just float and not actually create and/or keep a production schedule. Even if you only schedule two hours a day to create, be sure to maintain thst schedule in order to keep up on production. If you are anything like me then you have multiple talents/skills. If you get bored or stalled while working with one medium then switch to another medium or a different project in the same medium but always remain productive during working time. When you are consistently creating it is often easier to stay in the flow and keep creating as those brain muscles needed are used to working.

In the beginning, this might prove more difficult to do as it's very easy to become discouraged by the lack of motivation or when there's no client to work for. You need to know that working as an independent creative is a long-term process. Creating your personal brand has to be done step-by-step and there's really no way to rush it. You will start selling your products/services and you will find new clients, but you need to be patient.

If you can try to work in a separate space than where you spend your personal time. Changing environments can help signal your brain that it is time to work once you enter and help you focus on tasks. Plan when to work, when to rest and when to have free time. It's easy to be sucked into the 'always working' mentality, but instead of making things more effective, it can drain your creative energy.

Resetting your mind is an important part of the creative process and just as productive as replying to emails, doing your finances, or working on client projects. For me personally, it is important to get outside the house at least once during the day, either for a walk, drive, or for food. A change of scenery stops me from getting into a creative rut especially if I can get to a nature scene. Being around water works best for me for inspiration.

Find time for your finances. A lot of artists despise this part but it is difficult to get supplies to continue producing if there are no finances. You have to manage the money. Set up your price list and know what your profit margins are and what you make the most money off of. If you do not pay attention to the money it will feel neglected and it will not want to come around. No one likes to be ignored when they want attention, neither does your money.

Art Money

This is probably the part that most of us will find the most enjoyable, getting to the money. Income is important for both businesses and individuals and is typically required to eat unless you are someone's dependent. If you are like me then long gone are the days when you were a child and did not have to worry about bills and where your next meal was coming from. Now that you are an adult you have to figure out how to keep income coming in.

There are many avenues that you can explore in finding what works best for you to produce substantial sustainable income in the world of creatives. Most creatives have found a combination that works for them and they work with different mediums and funding sources for their projects as only having one might not produce sufficient income. For example, a painter might not only create/sell original and/or commissioned works but also teach painting classes through a school or private workshops to supplement income.

In the following sections, I am going to go through some ways to make money as a creative. Some will be tried and tested by time, some might be new to you and possibly more trendy, while the last batch might fall into the category of a reminder of some things we might take for granted or have forgotten about.

Originals

Creating original work is the oldest way of creating income as an artist/creative. You make something, you sell it. Simple. Repeat that process over and over. While creating for the sake of creating can be liberating as an artist the problem that can occur is that the artist is only creating for themselves. That artist now has to find or already know potential customers that have similar tastes or interest in that subject matter. This could lead to chunks of time passing in between finding buyers for your creative pieces and respectfully chunks of time passing in between good meals.

While I will always encourage an artist to create for themselves and whatever is inspiring them at that moment I will also always encourage an artist to create what someone is specifically asking for. Painting an original, commissioned piece guarantees that the piece will be sold, as it is already agreed upon before production even begins. When the agreement is made a deposit is typically given by the client before the work even begins relieving the artists of the responsibility of purchasing the materials needed and taking the risk of those materials going to waste by the work produced with them not being sold. Being paid beforehand can be a stress relief for most artists. Knowing that there is guaranteed money once the project is done can also help motivate the artist to complete the project sooner.

Prints/Licensing

The problem with producing an original "one-of-one" piece is that you usually only get the opportunity to sell it once. No matter how many hours, days, weeks, or months you put into it whatever you received from it has been received even if it is resold for a higher price in the future. What if you can be paid multiple times for producing the same work just the one time? Well, you can.

Making duplicates allows you to do just that. You can produce as many as you see fit and multiple people can have a piece of your work to suit their needs. The downside to this is that originals are valued higher than duplicates so the price points will be lower. The upside is that the price point allows for greater volume and often far surpasses just selling the one original piece, performance, or concept. If you want to limit the number of prints available you can set the limit and then number each piece to show the exclusivity. For example, you would write 1/10 or 3/10 on the back so the buyer understands that ten pieces exist and that they now own one of the only ten in the world. Limited prints also help raise/retain the value of your duplicates. If you want to get fancy you can also add special embossments on each piece to make it different from the others. Some buyers like the personalization.

Duplicates also cover digital images and other intellectual property. These can be licensed out to individuals or companies that are required to pay you either one lumpsum fee or per every time they use your intellectual property (royalties). So if you create an image and it is used on someone's product you can get paid per product which can be very

lucrative if the product is selling well. There is also the option to sell the image outright with all licenses included to stock image companies such as www.gettyimages.com, www.depositphotos.com, www.istockphoto.com, or www.shutterstock.com. If done wisely with quality work, this can be a steady stream of income that can quickly add up.

There is also more than one way to include prints into your inventory. You can either decide to invest and potentially tie up your money by paying to produce prints and then recouping your money later once they are sold or you can set up a print-on-demand service. With print-on-demand, you do not have to come out of pocket upfront for the print. Once an order is placed the print is produced and the cost of the production is deducted from your profit. This is the most budget-friendly option but is pretty much only effective in online marketplaces.

Classes

I wanted to make this section for my creatives that also possess the ability to teach. I know that the saying is "those that can't do, teach" but those that can do can also teach as well. In fact, if you can exhibit the skill set yourself it makes you even more credible and valuable as a teacher. More people will feel that they can learn from you if your skills are more advanced than theirs or you have achieved accomplishments/accolades in your career.

The teaching artist is highly valued these days. Being able to teach means that you can duplicate. Duplication can be a huge component of

efficiency. If you can teach two people how to do what you can do there will now be three people who can do it which means more can get done in the same amount of time. This makes you valuable to an organization.

Teaching artists, also known as artist-educators or community artists, are practicing professional artists who supplement their incomes by teaching and integrating their art form, perspectives, and skills into a wide range of settings. I myself have taught art history, graphic arts, drawing, painting, and stage play set design. According to www.ziprecruiter.com as of October 2020, an average salary for a teaching artist is $67,000 annually. That's not bad for barely working (because when you do what you love to do it seldom feels like work).

The Teaching Artist may perform for the students and teachers, may work in long term or short-term residencies in classrooms or in a community setting, or may lead in program development through involvement in curricular planning and residencies with school partners. The Teaching Artist is an educator who integrates the creative process into the classroom and the community.

Just a reminder, if you want to teach in most public school districts you will probably be required to obtain a teaching certificate. The schools I taught at were private schools, a vocational school, and a specialized school for music and arts that functioned more like special programming and operated after regular school hours and full-time during the summers.

If you cannot find somewhere that will pay you to teach what you have learned and/or been naturally endowed with then you can go to "plan B". You can create your own classes/workshops and offer them to the public. If you can secure a space to hold your classes in (or you are doing them virtually) then you can produce income by selling admission to your classes. This is easier if you are already known as a talented creative and people are interested in learning how to do what it is that you do. This can work with pretty much any medium. Photography (exposure, composition, lighting, editing), drawing (scaling, shading), painting (oil, acrylic, abstract, pop-art, knife work), sculpture (form molding, carving), poetry (cadence, imagery), crafting, writing, speaking, etc.

If you do not have a space, another good idea might be to conduct a destination workshop. You can have people meet you at the place that you will paint or take photos at or meet up and then travel there together. This can add the peaceful element of nature that reinvigorates and inspires a lot of creatives and also justify you not being inside of a building.

You can offer to teach pretty much anything that you can establish yourself as an authority on or at least prove that you know more than those you are trying to teach. Each creative form has multiple facets that you can run individual classes or workshops on so that you can teach more of the nuances and things that you would only gain through experience. Breaking them down allows you to increase your offerings as a teaching artist and increases your value.

Youtube

This goes right in-line with teaching classes. Youtube is a great platform to conduct instructional videos so others can learn from. Even better is the fact that you can both invite people you know or find to view your videos and random people that you didn't even know existed will also watch your videos. Even better than that is the fact that after a certain number of subscribers, views, and comments your video is monetized and you then receive royalties from youtube and/or advertisers.

Most YouTubers make their money off of Adsense, sponsorship, and affiliate links. Once your video is produced and published you can still be paid for it indefinitely as long as you live. This is great for passive income if you can make engaging videos on subjects people are interested in. Any traffic that you receive can be directed to your videos. You can also embed your videos into your websites and receive the video view once someone watches the video as well as the lick count for your website, so you score twice. Below are steps to follow that can help you along your path.

- Set your channel up for success. Choose a niche that you have experience in. Even if they do not know how to do something themselves most people can sniff out whether or not someone else knows what they are talking about. If you choose something you actually know not only can you provide valuable information in a video but you can make multiple videos because of the abundance of information you have on the subject.

- Do market research. Make sure that there are actually people who want to watch videos on your subjects. Go to Youtube and enter your subject(s) into the search bar. Make sure that videos populate and that they have at least an average of 10,000 views. You can use www.ubersuggest.com to obtain data on how many views your search words are receiving in order to help you gauge their popularity.

- Create a logo and channel art. Nothing elaborate is required here. Just try to make it as aesthetically pleasing as possible so people will want to stay on your channel longer. The main thing is that the finished product looks professional. If you need help on this www.fiverr.com is a good place to get it done for approximately five dollars.

- Generate the content. Now it is time to actually make the videos. This might be easier for some than others. If you are camera shy remember that you do not have to show your face. As long as the content is still visually engaging, entertaining, and/or informative you will retain the viewer's interest. Voice over videos that you have not made yourself also works in many cases (be sure to follow the fair use guidelines). Countdown (i.e., Top 10) videos and lists work well. You can pay for editing or an editing program or use a free one like www.openshot.org and rather than paying for music if you need it you can use the Youtube audio library.

- Upload and optimize. Your video is up, congratulations. Now that you have something worth viewing people are going to want

to view more. Create a content schedule to organize how often you upload to maintain consistency. Be sure to have your schedule be less than your production output to allow for room to make any adjustments or take personal time off from production while continuing to publish content for your growing viewership.

Be sure to research keywords and tags for your niche video so people can discover it. You can use a free Chrome plugin at www.socialblade.com to see what tags your competitors are using and then reuse those keywords in your video's description box.

- Get traffic. You can drive people to your videos from all of your social media channels, your email lists, social engine optimization (SEO), blogs, forums, and Youtube itself. My recommendation is to choose one channel and focus most of your energy on building that up.

- Monetize and make money. Your videos can be monetized directly on Youtube via the *Youtube Partnership Program.* Youtube will put advertisements on your videos and you will get paid for every time someone views the video. You need two things to be monetized: 1,000 subscribers and 4,000 hours of watch time. If you are consistently publishing videos you should arrive at these minimums much sooner than you would imagine.

If you do not want to wait for your channel to be monetized then you can also use affiliate marketing. You can put affiliate links in the description of your videos. You can find affiliate products by visiting

www.digistore24.com, www.clickbank.com, or www.affiliate-program.amazon.com.

This is also a perfect time to promote/sell any digital products that you might have. You can include links to your books or online courses that you created to boost sales.

Freelance

A freelance artist is self-employed and creates art for clients in exchange for a fee. They typically have multiple clients, work from home, and especially in the case of digital artists, may interact with their clients entirely online. The art is usually made to a client's exact description, as it will be needed for a specific purpose.

Personally, I like this option because of the flexibility combined with the responsibility. I am not one for routine and set work hours. With freelance work, you still have deadlines and certain requirements from your benefactors but you also can choose who you want to work with and what you want to work on. This can save you from doing anything that you have no interest in doing.

There is pretty much always a need for freelance artists because there is always a need for art in some form or fashion. Most companies do not have full-time artists on staff and might only need art at specific times so there is no need to hire a full-time artist but never-the-less they still need art. That is where you come in my friend.

Before you start freelancing my recommendation is that you start working for a company first. This allows you to build up experience, establish relationships, learn on someone else's dime, and be paid all the while. Starting out without any industry contacts can be a slick road to failure. Working for someone else first will teach you how to communicate with other people and clients, work on a deadline, and plan your time in the most efficient way.

If you develop personal and/or professional relationships with some of the clients that you serve while working for someone else, some of those clients might be willing to work with you and/or send other clients your way once you are working solely for yourself. This is a more ideal situation because It would be best for you to have a few clients already on your side before going freelance

Once you have a full-time job you need to be absolutely sure you are ready to quit. Cultivating your personal appearance in business will take you some time, so do not give up too soon. Give yourself a while to find clients and don't discourage yourself if/when there's no real income at the beginning. It is a process that may last a few months or even a year so be sure to save some money from the job you still have and wait until it's the right time to leave the nest.

What types of companies or people frequently hire freelance artists?

- Authors
- Publishers
- Film Companies

- Card Game Developers

- Board Game Developers

- Video Game Developers

- Start-up Companies (logos, business cards, pamphlets, etc.)

There are apps and websites that can help you find freelance work. Below I have listed some resources for helping you get started finding people to pay you to do what you love to do.

www.fiverr.com

www.upwork.com

www.freelancer.com

www.toptal.com

www.crowded.com

www.peopleperhour.com

www.simplyhired.com

Grants

If you're intimidated by the idea of applying for art grants, you're not alone. Long applications and complex criteria can make even the seasoned professional artist shy away. If you are anything like me then hearing the phrase 'apply for grants' raises my anxiety. I imagine forms with many pages and many lines per page. I am frozen with fear of getting the wording wrong or not knowing the proper language to get

approved and having all this form filling be a waste of time. I knew that if the application is not submitted correctly it will not even be looked at. I considered hiring help but my wallet gets tight at the thought of hiring a grant writer to write grants for me. I am writing to them to get money, I don't have any money to give someone to write the grant. It is supposed to be "free money"!

Now, as of this writing, I am still not a "grant writer" but I have dedicated time to learning much more about the grant process in the last three years than I have in the previous thirty. Don't tell anyone my age! I have learned that the process, while tedious, is much more simple than I originally let myself believe and that it can be easily duplicated from one grant to the next so that the energy needed is much lower due to our friends; copy and paste.

One of the things I want to be sure to debunk in regards to receiving grants is that you have to be a non-profit organization in order to be eligible to receive one. This is not always true. If you happen to have set your business up as a non-profit then you will have more opportunities but there are still plenty of grants that are offered to individuals and other business entities also.

I have learned that you should only include what has been requested. Oftentimes extra materials are either deleted or not reviewed. In some cases, it may disqualify your application which means you did all the work, plus extra, for nothing. I have learned that grants are not "free money" because they come with attachments. You have to follow

the grantor's rules, terms, and conditions when you are awarded a grant. You cannot use the money for what is not within the grant guidelines.

Grants can help your funding problems if you learn how to work them. Grants typically have cycles that allow you to receive them all year if you are receiving multiple grants. You can even be awarded the same grant in a different grant cycle if you qualify. Reminder: there is no such thing as free money. You will work for it by writing/applying for these grants.

Art grants fall into one of three broad categories. The first is for general business development and growth, in which the grant is awarded to an artist for the purpose of growing their overall art business through a variety of means, sometimes including a mentorship or "incubator" program in addition to a cash award.

The second type of grant is project development. These grants usually provide funds to research, develop, and complete a specific project such as a show, installation, or particular series or collection of works. These grants are often awarded to artists working in various modes of activism or works with a high level of benefit to the community. Socially conscious art is the most successful with these grants.

The third category is unrestricted funds. Professional and project-development based grants typically cannot be used for immediate financial needs like rent, but unrestricted funds take the shape of a simple no-strings-attached cash award. A few require the artist to

demonstrate immediate financial need, while others are simply awarded to artists excelling in their field.

Below is a shortlist of grants that are available to full-time entrepreneurs like yourself to help you get started funding your life/lifestyle.

Grant/Award	Organization	Website
Creative Capital Award	Creative Capital	https://creative-capital.org/about-the-award-application/
Individual Support Grant	Gottlieb Foundation	https://www.gottliebfoundation.org/individual-support-grant-1/
Grants for Visual Artists	The Harpo Foundation	http://www.harpofoundation.org/apply/grants-for-visual-artists/
Lyndon Emerging Artist Program	Contemporary Craft	http://contemporarycraft.org/opportunities/artist-opportunities/
Awesome Grant	The Awesome Foundation	https://www.awesomefoundation.org/en/about_us

Global Art Grants	Burning Man	https://burningman.org/culture/burning-man-arts/grants/global/
Individual Artist Grants	Ruth & Harold Chenven Foundation	http://chenvenfoundation.org/how-to-apply/
Project Development Grant	Center	https://visitcenter.org/project-development/
The Anything Art Grant	Spectro Art Space	https://spectoartspace.com/anything-art-grant/
Individual Awards	SustainableArts Foundation	https://apply.sustainableartsfoundation.org/

Fellowships

A fellow (non-binary) is a member of an academy/learned society or a group of learned subjects that works together in pursuing mutual knowledge or practice. A fellowship grant is generally an amount paid or allowed to an individual for the purpose of study or research. The terms "scholarship" and "fellowship" are often used interchangeably to describe a grant or another type of funding for academic achievement. More often than scholarship awards, fellowship grants will include an internship or other service commitment, often for a period of one or more years.

There are many different kinds of fellowships, which are awarded for different reasons in academia and industry. They often indicate a different level of scholarship. A fellowship is typically a merit-based scholarship for advanced study of an academic subject. If you want formal education to increase status or to get better at doing what you do then fellowships are a great option.

While many fellowships are tailored toward post-graduate study, there are also a significant number of undergraduate fellowships available. Fellowships can range from short-term programs (months) to multi-year commitments. Some fellowship awards are limited to specific areas of study, while others are open to all outstanding students. You'll find both independent programs and school-specific fellowships. Not only do fellowships provide funding, but they are also usually quite prestigious. Winning a spot in a fellowship program is very competitive, as they are designed to give students the chance to focus on academic research and access development opportunities that will help students make contacts and significantly advance in their course of study.

Receiving a prestigious fellowship also looks good on your resume. Fellowship applications can be quite extensive and may even require additional steps like a nomination, interviews, and presentations so be sure you are willing to put in the work. Again, no such thing as "free money".

The fellowship programs may be hard to get, but are associated with many benefits including:

- Practical Experience – The unique responsibilities and project work associated with a fellowship program will help you develop the skills and experience required to work in a real job. Many employers consider the fellowship in lieu of entry-level work experience. This may help you get a better job after graduation.

- Professional Development – Fellowship programs also offer extensive professional development opportunities to graduate students. You will learn public speaking, community organization, grant writing, media relations, and leadership skills. You will participate in seminars and conferences across the globe.

- Financial Support – Fellowship programs are also associated with monetary benefits. Most students receive $10,000 to $25,000 for a 9 to 12 month program. This is a significant allowance and is usually equivalent to a full-time job.

- Additional Incentives – Many organizations offering fellowship programs also provide additional incentives such as health insurance and housing. The extent of compensation and the type of incentives depends directly on the terms of the program.

- Tax Benefits – United States citizens and permanent residents are not required to pay any taxes on their fellowship earnings. The Internal Revenue Service or IRS, however, charges 14 percent tax from all international students receiving fellowships.

- Research – Fellowships are great for students who wish to pursue research in a specific field. The award will not only provide you with financial assistance, but it can also add

credibility to your research and inspire other organizations and foundations to fund you as well.

- Personal Confidence – Winning a prestigious fellowship will ultimately boost your confidence and motivate you to take up leadership positions at top universities or corporations.

Contests

Contests are a good way to create energy, momentum, and money for your business. You can both enter existing contests and also create your own. Entering contests and winning can bring you income if prize money is offered or in many cases offer some prestige and recognition for being the prize winner. Raffles for pieces that you have already produced can generate enough money to pay for your asking price of the piece and sometimes even more than you would have asked a single potential buyer for.

You can use your existing channels to promote the contest to get more participants. Be sure to make one of the rules to enter the contest be to promote the contest to others. This way every time someone enters the contest there is potential to get even more contestants that you did not have access to nor had to work for. Contests provide incentivized interaction that can drive traffic to your designated location, generate new email leads, and (if you have a complete campaign strategy) make sales.

To run a successful contest, you need to know your goals. There is really no shortage of strategies for how to run a contest. So, drive your

success by defining the outcomes you need. Your contest's goals should be aligned with your business and marketing objectives.

Here are 8 top contest goals:

1. Drive more traffic to your site
2. Increase buzz around your brand or new product launch
3. Generate new email leads
4. Develop customer relationships/deliver value to customers
5. Gain immediate sales
6. Increase engagement levels on social media
7. Get user-generated content (from photo/essay/video contests)
8. Gain insight into popular products

Types of contests:

Sweepstakes - These are the easiest for people to enter, and to win. The prize is key to getting lots of people to enter.

Vote Contests - These also have a low barrier to enter (so you'll get more participants). Give customers choices to vote on, and to be heard by your company!

Photo Contests - These contests have a slightly higher barrier to entry, as you're asking for people to give you their photos. They are a lot of fun and can get you tons of user-generated content.

Essay Contests - These generally ask a little more from participants. You're asking people to write a few words about a topic you choose.

Make the topic brand related to get more feedback from entrants, or get more brand awareness.

Video Contests - These ask your entrants to make a video and submit it to you. Like a photo contest, video contests can be a lot of fun, and you can get lots of user-generated content, and even some customer insights! Include a voting element to get more people engaged with video contests.

Coupon Offers - These are easy to enter, like the sweepstakes. They give your business immediate sales. If you are not sure which type of contest you want to run, try one out, or try out a few, and see what works best with your business and target market.

Books

This, of course, is one of my favorites. This book that you are reading now is my second full-length book. If you still have not read the first installment of this series, "Tripping Over Canvases: How to Open Your Own Art Gallery With No Prior Experience" then you are missing out! Even if you do not want to own a physical location it contains valuable information about online galleries and other money-making setups. (Shameless plug)

Most people often think writing books is a daunting task and it can be. That is if you are actually writing. Let me explain. When I am putting together these books I am talking more than writing. I am literally imagining myself having a conversation with someone about these topics and disseminating the information orally. I can either take notes of what

I am saying or record myself and then later write almost verbatim what it is I said earlier. I have always found this was an easy way to get past writer's block as well. People might run out of things to write but we seldom run out of things to say. So I talk rather than write. You can always go back and finely tune and polish what you produced. With this technique, I could write a book a month, if I knew how to type with more than four fingers.

Before I started writing full books I began writing Ebooks. These were on short niche topics and contained very concentrated information. They were actionable, straight to the point and they only totaled 5 to 7 pages each, making them very easy to complete. Completing each one I got that feeling of accomplishment and the right to brag about having written a book. My first Ebook was "How to Stand Out: How to be Different Than The Other 100,000 Artists" (available on www.amazon.com)

I used the Ebook to both make money and collect emails. Through my social media channels, I offered the Ebook for $1 if you gave me your email. This allowed me to be paid immediately and also have the ability to contact people who are interested in my field and/or who want to support me and might be likely to do it again in the future. I would later raise them to $3.99, especially once people informed me that following the advice increased their income I realized it was worth it.

This motivated me to do it a few more times and led me to realize that if I can write five Ebooks then I could write a full-length book because it could really be five more Ebooks put together (this is how I

talked myself into it). When the second Ebook was completed I emailed all those who purchased the first one then made the same offer again on social media as I made on the first one to gain more new customers. Releasing the Ebooks increased my perceived expertise in my field and started my journey on becoming an authority in my market on artrepreneurship.

The best part about creating any type of book is that it is typically inexpensive to produce. There are many print-on-demand options that make it so you do not have to come out of pocket for upfront production costs. The cost of making the copy is deducted from the sales price and the author receives the difference. This also means that you do not have to worry about carrying or storing inventory. Once you have created it, it will be forever available for purchase. As long as you make it discoverable people can find it and purchase it years or decades later and you still get paid for it. Books are a good form of passive income.

Being an author, even if it is only an Ebook (it counts), can open many doors for you and bring additional opportunities for income and expanding your network. I have been paid to speak and asked to teach classes/workshops on subjects that fall into my area of expertise. I have been asked to join judging panels and even invited to be on boards of established art organizations due to my voice being heard (or read). I would definitely suggest everyone write a book at some point in your career about something, anything!

Rent your art

This is not the same as licensing your art per se. In this situation, someone or some business has your art available for display in a place where their potential customers can view it. Both parties have come to an agreement on the amount of time the artwork will remain on the premises. At the end of the agreement duration, the artwork can then be switched out for another piece of artwork at that time. You can charge them for the monthly rental or you can make other mutually beneficial arrangements with them.

For example, you can agree with a doctor's office to display your artwork in their lobby. Your selling points will be the upgrade in aesthetics, feng shui, dopamine, serotonin, or whatever you come up with (it's sales, be creative). The doctor's office will display your name, contact info, and the price of the piece on the label. This will get increased exposure for your piece and increase the chances of it being sold, especially if you can do this in an affluent area where the populus has a considerable amount of disposable income.

If someone buys the piece you can keep the full amount and just replace the piece for the doctor's or lawyer's office with another loaner or your arrangement can include a small commission for them. This can be both a selling point to seal the deal and also an incentive for them to push the pieces to their clients. Either way, it's a win-win. They get to look good and you get to make money and grow your list of collectors.

Festivals/Fairs

Traditionally this is how most artists made their money over the past few decades. With art being a more emotional and personal purchase most of it is sold once it is seen physically in-person. The easiest way to do this way to have it displayed where large groups of people could see it in a very short span of time. With the introduction of COVID-19, the world has changed. There will probably be very few if any, large gatherings of people to fill festivals and fairs so that avenue does not have the same weight that it previously had.

In 2015 art fairs generated an estimated 12.7 billion in profits for exhibiting galleries and artists and seemed to be increasing each year until 2020. That probably will not happen again. The alternative today is to submit to open art calls and become a part of virtual group exhibitions and art tours. This can get you some similar exposure and also allow you to possibly enter the same image (since it is digital) to multiple virtual fairs to increase the chances of it being sold. If it sells from multiple platforms it is on you how you handle that. I will not advise you on how to proceed. Be honest, transparent, and most importantly be creative!

Open a gallery

This is another avenue I have taken and am still currently in. My gallery, Above Art Studios, has been in existence for five years at the time that I am writing this.

Sponsorships

Corporate sponsorships are a way to make you strong and give you the resources you need. They can also add to your company's credibility. It is important that you publicize your corporate sponsors on your flyers and website to let people know you are playing at a higher level in business.

This is an area that most artists have no idea about. Finding and obtaining sponsorship, to me, was something only athletes and established organizations could accomplish. Little did I realize that it is surprisingly easy to accomplish. Now, you may not start off with large brands or large packages or checks but there are plenty of companies that are willing to help you if you just reach out and ask.

Just reach out and ask? Yes, it is that simple. It might be met with a no but it does not hurt to ask and "no" is the worst that they can say to you. The more sponsors you reach out to the higher the chances of obtaining sponsorship. The key is in how you ask. You have to be sure to have a great sponsorship proposal. Do not overthink it. This is just emailing the company a regular letter. Below are tips to increase success.

- Start with a story. It could be your story, or the story of someone whose life you changed. Whatever you do, tell a story. This will get your proposal to stand out and make an emotional connection. There is a person in the company you approach who is going to make a decision about whether or not to sponsor you.

That person has to make both a business and an emotional decision to give you the money.

- Describe what you do. This is your mission statement. It explains why you do what you do.

- Benefits. You need to have really great benefits for the sponsor you are approaching.

- Describe your demographics. Your demographic is the market you are after, and you want to have statistics about that market at your fingertips. Find out the spending power and purchasing habits of your target market. Research the median income and educational level. Show your knowledge.

- Ask for the money. Companies do not call you to ask how much money you want. List price options and your offerings for each option.

- Promise deliverables. Don't just promise media coverage -- promise specific media coverage, e.g.: "I will give you media coverage in the hometown business journal. It has a circulation of 60,000 people making more than $100,000 a year,".

- Don't sell yourself short. Don't ask for $100 unless you ask a mom and pop store on your corner. You are wasting a corporation's time by asking for small amounts. The write-off is not worth the time the corporation has to put into making it happen. Ask for larger amounts. Don't be scared.

Printed in Great Britain
by Amazon